LONDON
JOURNAL

David Long

LONDON JOURNAL

A Guided Tour and Diary of Discovery

Illustrated by

Kate Forrester

Michael O'Mara Books Limited

Introduction

A guide book can never be any more than that – a guide – because in order to really get under the skin of somewhere as vast and as historic as London, it is important to be out there finding things for yourself.

In the following pages you'll find recommendations of places people like to go and keep going to, whether they are Londoners by birth or by adoption, or simply visiting. Some locations are well known, others less so, and more than a few are the type of spots that get described as 'one of London's best-kept secrets', although usually by people who can't wait to tell everyone else what they now know.

But this is also a journal and, as such, alongside these recommendations you'll find space to record your thoughts on them or, even better, to note other places you were inspired to discover for yourself after reading the suggestions. London, after all, appears differently to different people, and in a real sense we make of it what we want. Of course, there are stops along the way that everyone has to make – the globally famous landmarks, the most celebrated bars and restaurants – but people who really love London will tell you that the best places are the ones you find yourself, and this is the book to start you on that journey.

David Long

LOOKING DOWN ON LONDON

Loathe it or love it, the Shard is the headline for now, but a trip to the top can be expensive, especially as you have to book far ahead and might find the allocated day is a foggy one. In truth, the best views aren't necessarily from the tallest buildings, and some of them won't cost you a penny.

Sky Garden (525 feet), *Fenchurch Street, City*

An appointment is also needed to visit this spectacular triple-height glasshouse; however, there's no charge due to its being a quasi-public space. The panoramic 360-degree view is stupendous, although anyone suffering from even mild vertigo will find peering over the edge of the terrace a deeply disconcerting experience.

Westminster Cathedral (273 feet), *Victoria Street, Westminster*

One of the capital's least-known viewpoints, the campanile or bell tower affords far-reaching views across central and west London for anyone visiting this glorious, richly decorated Roman Catholic corner. No glass in the windows means there's usually a strong breeze even in summer, but it's perfect for photographers hoping to capture a bird's-eye view.

One New Change (112 feet), *New Change, City*

Don't be fooled by the relatively modest height: the terrace on top of this strikingly modern shopping complex provides one of the best views possible of St Paul's Cathedral and a vast panorama of London. Free to visit seven days a week, its size means it's rarely, if ever, crowded.

HISTORY on a PLATE

In a city as vibrant and fast-moving as London, few things change more rapidly than culinary fashion. Food fads come and go and starred chefs explode onto the scene with a dizzying regularity. Change seems to be the only constant, yet a few great names endure, the best of them for more than two hundred years.

Rules (1798), *Maiden Lane, Covent Garden*

Now well into its third century and still on its original site, the doyen of dining rooms is spoiled only by the lack of a dress code. The elegant picture-hung Edwardian interior and clubby menu can seem at odds with its clientele, but with a jacket and tie no longer *de rigeur* the place has never been busier.

Wiltons (1742), *Jermyn Street, St James's*

Wiltons opened for business ahead of Rules, but initially as a fish stall rather than a first-class restaurant. Plush, hushed but unstuffy, its many regulars seem not to mind the prices — and the beguiling atmosphere and flawless service mean you won't either, at least until the bill arrives.

Sweetings (1889), *Queen Victoria Street, City*

Serving weekday lunches only, Sweetings caters for busy fish-loving City types who don't want to hang around. The décor is simple and what the cooking lacks in sophistication it makes up for with the quality and freshness of the expertly sourced ingredients.

M. Manze (1902), *Tower Bridge Road, Southwark*

A third-generation family-owned eel, pie and mash shop; pies freshly baked each day make this the authentic home of cockney comfort food. For centuries the eels somehow survived the polluted Thames water before being stewed or jellied, but since the 1800s most have been imported from the Netherlands and Northern Ireland.

ROMANTIC RUINS

Staggering land values mean ruins do well to survive at all in London, but those that do provide a fascinating glimpse of the past as well as somewhere magical to wander through.

Christ Church Greyfriars, *Newgate Street, City*

This soaring Wren tower survived the Blitz to become an extraordinary eleven-storey private house, but the nave was ruined in December 1940 and now encloses a small public garden. Beneath it are buried the remains of three queens, two of England and one of Scotland, and the heart of a fourth: Henry III's widow, Eleanor of Provence.

Lesnes Abbey, *Abbey Road, Bexley*

Unique among the religious foundations that once thronged London, it is still possible to discern the outline of this twelfth-century Augustinian abbey, even though the walls rise only a few feet out of the grass. When it was granted to Cardinal Wolsey following the Dissolution, most of the stone was sold off to fund what became Oxford's Christ Church College.

St Dunstan-in-the-East, *Idol Lane, City*

The delicate Gothic steeple mounted on medieval St Dunstan's happily withstood a devastating hurricane that struck London in the early eighteenth century. Unfortunately, the church itself was badly damaged by German bombers, after which the decision was taken to stabilize the ruins rather than rebuild them.

Winchester Palace, *Clink Street, Southwark*

A beautiful rose window was discovered by chance after a nineteenth-century warehouse fire. Today it is the most visible remnant of a great hall used by the bishops of Westminster for more than 500 years, and is believed to be where Henry VIII first met wife number five, Catherine Howard.

Secret Gardens

For decades, ruined St Dunstan's (see previous page) has concealed a peaceful haven of climbing plants and park benches. One of many hidden spaces in the square mile, it is open to anyone but jealously guarded by those in the know, who like to sneak off to enjoy an unhurried lunchtime sandwich while catching up with the news.

The Phoenix, *St Giles Passage, Borough of Camden*

Situated immediately above Shaftesbury Avenue, this award-winning community garden was created in 1984 on the site of an old car park. Formerly the grounds of a long-vanished leper hospital, the combination of lush planting and cool ponds is an extraordinary thing to find so close to the heart of the West End.

Kyoto Garden, *Holland Park, Kensington*

A gift to London from a Japanese business organization in 1991, the garden displays all the favourite elements of Oriental garden design, including tiered waterfalls, maple trees, stone lanterns and a pool teeming with exotic koi carp.

Temple Gardens, *Victoria Embankment*

The porters guarding the entrances to London's famous legal enclave seem to be there to put you off, but walk on through. Inside you'll find almost three acres of colourful herbaceous borders and tranquil sweeping lawns, which visitors and the public are free to enjoy on a weekday afternoon.

CULTURE after HOURS

School parties and large tour groups can make the best museums and galleries difficult to navigate during the day, but several host after-hours events, often with special themes to attract the regulars who may think they've seen it all.

Sir John Soane Museum, *Lincoln's Inn Fields*

The great architect's beguiling labyrinth may no longer be London's best-kept secret, but it is still a rare treat. On the first Tuesday of the month the first 200 in the queue – fortunately not all at once – can see the place as he would have: by candlelight.

Science Museum, *South Kensington*

Wednesday evening openings include a series of talks, workshops, entertainments and installations. Entry is free and for adults only, which keeps down both the numbers and volume of noise.

Apsley House, *Hyde Park Corner*

Twilight, torch-lit tours of the Iron Duke's townhouse and gallery each October offer a unique way to enjoy the outstanding collections displayed in this familiar London landmark.

Guildhall Art Gallery, *City*

This superb little gallery, largely ignored by tourists, opens late on Friday evenings four times a year, when it is also possible to visit the fabulous Roman amphitheatre, which was discovered in the basement less than thirty years ago.

ART DECO DELIGHTS

Hear 'Jazz Age' and one thinks of America and Jay Gatsby, but here too the inter-war period saw plenty of new building, with some fascinating survivors.

Claridges, *Brook Street, Mayfair*

Far older than the Ritz and less showy, this Victorian structure was brilliantly recast by Basil Ionides in the 1920s, and his opulent art deco style has never been bettered. Serving as an effective annex of Buckingham Palace during the war, it was home to at least half a dozen European royal families, and at the time of Elizabeth II's coronation hosted so many crowned heads that when a caller asked for the king, the receptionist had to ask which one.

Palladium House, *Argyll Street, Soho*

Formerly Ideal House, this extraordinary black granite block was the HQ of the American National Radiator Company. The severity of its austere rectilinear shape is alleviated by colourful enamel decoration designed to echo the corporation's black and gold trademark colours.

Broadcasting House, *Portland Place, Marylebone*

Its gleaming white façade a beacon for German pilots, the home of the BBC survived a 1940 bomb to become one of London's most familiar, if mysterious, landmarks. The exterior carvings were made in situ by Eric Gill while wearing a monk's habit … with nothing underneath.

Southgate Tube Station, *Enfield*

This large, elegant Streamline Moderne drum with a projecting glass and concrete roof is a Piccadilly Line favourite. Architect Charles Holden designed numerous others for the network, describing them as simply 'brick boxes with concrete lids', but in reality showed himself to be the materials' master.

William Somerset Maugham spent most of his life in France, insisting that to eat well in England one should order breakfast three times a day. Notwithstanding the likely loss of Simpson's-in-the-Strand and its weighty Ten Deadly Sins, London offers considerable choice for anyone who likes to make the first meal of the day count.

Bad Egg, *Ropemaker Street, City*

The portions here are fairly modest, but for the all-in price you get three separate breakfasts in one and as much Bloody Mary as you can drink within a two-hour period. If that sounds like bad news for global financial stability, readers will be relieved to hear this so-called bottomless brunch is markedly more popular at weekends than during the week.

Kipferl, *Camden Passage, Islington*

It's impossible to beat a proper full English, but what our continental cousins call *bauernfruehstueck* – a traditional Austrian stir-fry of potatoes, onions, bacon and eggs – certainly hits the spot on those rare occasions when you fancy a change but can't face a kipper or kedgeree.

Regency Café, *Regency Street, Westminster*

Nothing can dent the appeal of the traditional greasy spoon, and of the hundreds in London, this one is always rated highly by those who know their fry-ups. Loud but friendly and still in business after more than half a century, it deserves to be on every visitor's to-do list for the next fifty years, too.

BRILLIANT BOOKSHOPS

If it's true that the only way to compete with the internet is to offer something niche and distinctive, bibliophiles have good reason to hope it will still be possible to lose an afternoon browsing bookshops in London for years to come.

Tales on Moon Lane, *Half Moon Lane, Herne Hill*

'Where Alice would have found her Wonderland' is how one customer described this amazing children's bookshop. Enthusiastic, knowledgeable staff and a very full programme of readings delight children and adults alike and make it well worth the journey south.

Joseph's, *Finchley Road, Temple Fortune*

You don't have to be Jewish to shop here, but it helps. British and world literature are well represented, but there's a strong focus on Jewish and Israeli interests, reflecting as a good shop should the educated sensibilities of its owner. Readings, events, live music and a wonderful café make it somewhere to visit again and again.

Daunt Books, *Marylebone High Street, Marylebone*

The unrivalled triple-height travel section has the widest possible array of hotel, flora and fauna guides as well as phrase books, travel writing, and national histories. A light and airy space makes it a pleasant change from the traditional book cave.

Heywood Hill, *Curzon Street, Mayfair*

The best bookshops have their own stories, and none more so than this famous Mayfair landmark, which Evelyn Waugh described as 'a centre for all that was left of fashionable and intellectual London' when Nancy Mitford ran it in the 1940s. It is still a literary haven today.

GAMES to PLAY on the TUBE

Travelling to school in the seventies, the author and friends greatly irritated more grown-up commuters by racing from one end of a carriage to the other without touching the floor. More sophisticated challenges have since been devised, most of which are considerably harder.

The Tube Challenge

This mad non-stop dash to visit every single station on the London Underground takes a good deal of planning and a certain fitness to complete. At the time of writing the record, independently audited for all 270 stations, was a mere 16 hours, 14 minutes and 10 seconds.

Circle Line Pub Crawl

Exactly what it sounds like: competitors visit the pub nearest to each of the twenty-eight stops, attempting to drink a pint in as many as possible before collapsing in a heap.

Man v. Tube

Another Circle Line event: a race on foot to beat the train by jumping off at Mansion House and sprinting to Cannon Street before jumping back on the same train. People, it can be done.

Animals on the Underground

Paul Middlewick was the first to spot a bunch of slightly angular animals hiding out in Harry Beck's classic Tube map. Next time your train's late, see if you can find an elephant, ostrich or fox in there, marked out by the lines that make up what is now considered a design masterpiece.

Museums of the UNEXPECTED

For something a bit more unusual, seek out some of the slightly obscure museums, any one of which has much to offer those prepared to abandon South Kensington for an afternoon.

Bank of England Museum, *Threadneedle Street, City*

It's all about the money, which turns out to be surprising stuff with a long and fascinating history. Visitors can't see the vaults beneath the bank (where more than 5,000 tonnes of gold are stored, worth well in excess of £150 billion), but there's always a bar on display that you can handle.

The Grant Museum of Zoology, *University Street, Bloomsbury*

Among thousands of rare and extinct specimens, favourites include a jar of pickled moles, the skeleton of a quagga and London's largest collection of preserved brains. Also, the remains of a giant five-metre anaconda formerly resident at the Regent's Park zoo.

Museum of Freemasonry, *Great Queen Street, Covent Garden*

The place is fascinating, likewise the list of famous masons past and present, but this has not prevented cynics suggesting the real HQ is somewhere else and that the museum is simply an ingenious exercise in disinformation designed to throw us off the scent.

The Cinema Museum, *Dugard Way, Kennington*

A former projectionist's obsession with movies encompasses everything from the stars and their films to costumes, publicity stills and posters; even the uniforms the usherettes wore while showing latecomers to their seats.

the WHEELS on the BUS

Like the original Mini, it's doubtful anyone really prefers the so-called New Routemaster to the old one, and many still catch the No. 15 precisely because it's the only route that uses traditional open-platform buses. The alternative is to jump on a tour bus, as several companies are giving the old girls a new lease of life.

The London Ghost Bus

Nicknamed the Necrobus, the company's distinctive black Routemaster traces a path around places associated with murder, torture, execution and the paranormal. Designed to amuse as well as scare, the guides promise to liberate more than a few famous skeletons from the capital's cupboards.

London by Night

Exactly what it sounds like. The usual tourist sights and no real surprises, but London looks so different after dark and the top of a bus is a great place from which to view it.

The Bond Bus

007 briefly took the wheel of a Routemaster before wrecking it in *Live and Let Die*, and now his fans can visit key locations from films old and new. Commentary and discussion on board includes plenty of spy trivia and there's a chance to see a few places associated with real-life espionage from the Cold War days.

London Duck Tours

Admittedly more of an old-fashioned charabanc than a bus, a fleet of ex-military amphibians – some of which saw action as part of the D-Day landings – travel the streets of London before dipping into the Thames for a novel view of the city.

NOT ALL LONDONERS ARE HUMAN

Londoners are made as well as born, and among those who have been adopted and are most loved by the locals are some surprising individuals.

The Horniman Walrus

A star exhibit in the popular south-London Horniman Museum for more than a hundred years, *Odobenus rosmarus* arrived from Hudson Bay in the 1880s when the animal was much admired by the Royal Family. The specimen is considerably larger than most and only recently has it been recognized that this is because the taxidermist was somewhat over-enthusiastic when stuffing the poor beast.

Guy the Gorilla

Resident at London Zoo from the late 1940s until his death more than thirty years later, Guy too was stuffed, and today this prime example of a western lowland gorilla can be seen at the Natural History Museum. (The squeamish might prefer the bronze statue of him situated by the entrance to the zoo or another in Crystal Palace Park.)

Rip the Rescue Dog

This scruffy terrier was adopted in 1940 by a Poplar air-raid warden and had an uncanny knack for finding Blitz victims buried beneath the rubble. How many lives he saved is impossible to know but Rip's tenacity, skill, determination and courage convinced the authorities to train more dogs to do the same, the predecessors of today's search-and-rescue dogs. Awarded the rare Dickin Medal (known as the animals' VC), Rip did not survive the war and is buried in Ilford, Essex.

CSI LONDON

With murders in the capital at an historic low, the most notorious crime scenes still exercise a gruesome hold over the public, even though in most cases there is rarely much to see.

Jack the Ripper, *Mitre Square, City*

Jack's victims mostly came to grief in Whitechapel but one, Catherine Eddowes, was murdered here in the Square Mile. A colourful flowerbed now marks the spot, but while there are many quite ludicrous theories about who did it, the mystery is no closer to being solved than it was 130 years ago.

Hawley Harvey Crippen, *39 Hilldrop Crescent, Tufnell Park*

The house where Dr Crippen did away with his wife in 1910 was destroyed by enemy action thirty years later. Crippen was hanged after a failed attempt to escape across the Atlantic, but his secretary, lover and co-accused, Ethel Le Neve, lived on until the late 1960s.

Ruth Ellis, *The Magdala, South Hill Park, South Hampstead*

The last woman to be hanged for murder in Britain shot her boyfriend outside this pub in 1955. It is by no means clear whether or not the 'bullet holes' still visible in the walls are genuine but, curiously, it is just yards away from the home of Styllou Christofi, the penultimate woman to hang, who battered her daughter-in-law to death and burnt the corpse.

7th Earl of Lucan, *Lower Belgrave Street, Belgravia*

Accused of murdering his children's nanny after letting himself into the family home at No. 46, the likelihood is Lucan mistook her for his estranged wife. He probably drowned in the English Channel, although conspiracy theorists much prefer the idea that he was spirited away to safety by rich and powerful Establishment friends.

GRAVE concerns

Dead Londoners are reckoned to outnumber live ones by a factor of at least ten. Even so, the authorities have shown considerable style when it comes to their disposal, and some of the capital's cemeteries are now wonderful places to wander through.

Kensal Green Cemetery

Victorian England's first and most fashionable Valhalla was described as the 'Belgravia of Death'. Once two of George III's children had been interred here, aristocrats, magnates and celebrities followed their lead. Look for retailer W. H. Smith's grave: a vast carved book.

West Norwood Cemetery

With around seventy Grade II and II* listed buildings and monuments squeezed onto a sixteen-acre site, the cemetery seems to have been popular with inventors, architects and engineers. The grave to find: Sir James Greathead, whose ingenious tunnelling shield made it possible for London to excavate the world's first deep-level underground railway.

Highgate Cemetery

Should we be surprised Karl Marx ended up in the country's most exclusive and expensive cemetery, or indeed that so many of his supporters joined him here? Hypocritical or not, it is a splendid spot. Seek out musician Harry Thornton's stone grand-piano grave.

Brompton Cemetery

This is where they buried Sioux chief Long Wolf when he died on tour with Buffalo Bill's Wild West Show in 1892. A hundred years later his body was exhumed and repatriated. The grave to find is that of racing driver Percy Lambert, who crashed at Brooklands in 1913 and was buried in a coffin streamlined to match his car.

LONDON under LONDON

Beneath London there lurks a whole other city. Besides hundreds of miles of Tube tunnels, several fortified military command centres and supposedly bomb-proof bunkers, there are old mine workings, lost rivers, a former tram station and even the remains of a top-secret underground aircraft factory.

Chislehurst Caves, *Bromley*

Despite the name, this thrillingly maze-like warren is entirely man-made, flint and chalk miners having excavated miles of passageways over several hundred years. Since closing in the nineteenth century, it's been an ammunition depot for the Royal Arsenal at Woolwich, a concert venue, a mushroom farm and an air-raid shelter complete with hospital and chapel.

Park Hill Tunnel, *Croydon*

A small, sad relic of London's many failed railways, the Woodside and South Croydon Joint was an attempt to link London and suburban Surrey. But fatal competition came from trams, which is ironic as the route is now used by the reborn South London Tramlink.

Took's Court, *City*

This giant subterranean 'atom-proof' telephone exchange once formed a vital link in the famous White House–Kremlin 'hotline'. Behind an anonymous entrance on High Holborn, accommodation was provided for 150 staff with supplies for a six-week lockdown should World War III break out.

Crystal Palace Subway, *Bromley*

When the great 1851 showpiece was moved from Hyde Park to Sydenham Hill, a new railway was installed for visitors. Little of it has survived besides this marvel of decorated brickwork, with fifteen hollow columns supporting dazzling white and terracotta fan vaulting.

THE BEST VIEWS of LONDON

Even the most ardent lovers of London will concede that much of it looks best from a distance, and within its approximately six-hundred square miles there are a number of elevated spots from which the view is genuinely breathtaking.

Parliament Hill, *Hampstead*

Originally Traitor's Hill, this popular south-eastern corner of Hampstead Heath eclipses both Alexandra Palace and nearby Primrose Hill as the place to see across what feels like almost the entirety of the London basin. The old name is a nod to the Gunpowder Plotters, whom local legend says were planning to watch Parliament burning from here.

Crystal Palace Park, *Bromley*

It's hard to overstate how wonderful these Victorian pleasure gardens are, but like the nearby Horniman Museum and its gardens, only those living in the immediate vicinity seem to know this. The views of London to the north, south and east are particularly good.

Greenwich Park, *Greenwich*

From the high hill outside the Royal Observatory, the panorama is stupendous, with picnickers and others massing here in the summer to take in the Queen's House, Wren's Royal Naval College, Canary Wharf and the City of London. Bring your binoculars.

Isle of Dogs, *Tower Hamlets*

Barely at sea level, but the view back across the river to Greenwich encompasses London's finest architectural set-piece. The best way to reach it is through the foot tunnel accessed via the dome by the *Cutty Sark*.

HISTORIC MARKETS

London still boasts scores of traditional street markets, and those who frequent them can spend hours arguing over which is best. Many specialize and some have done so for centuries.

Columbia Road, *Bethnal Green*

Selling flowers, plants and a cornucopia of things horticultural, in the late-nineteenth century the market replaced an extravagant Gothic Revival complex of covered stalls. This had been built in an attempt to bring London's costermongers in from the cold, but they preferred the weather and soon drifted away.

New Caledonian, *Bermondsey*

Famous for antiques, objets d'art and leather-bound books – and for an ancient law allowing buyers to receive stolen goods without fear of prosecution. Incredibly, the law was repealed only twenty years ago, but the market continues to do good business with those arriving before sunrise armed with pocket torches to spot a bargain.

Brick Lane, *Shoreditch*

Everything from junk to gems is the usual description of this loud, crowded, bustling East End institution. Clothes, vintage and modern, furniture and household goods – anything that people want and on which the canny traders can turn a profit.

Greenwich, *Greenwich*

What began as a modest craft market now regularly attracts a couple of hundred stallholders selling their own often exquisitely made textiles, jewellery and gifts. The buskers are among the best anywhere and countless street-food sellers means one visit won't be enough.

FINE OLD SHOP Interiors

The displays in the Harrods food hall deserve the praise they get and it is easy to see why so many go to look rather than to buy. But in and around Jermyn Street are several other retailers with premises at least as remarkable, if inevitably much smaller.

Floris, *St James's*

The polished Spanish mahogany display cabinets were built for the Great Exhibition of 1851, but this Royal Warrant perfumer opened for business almost a century earlier than that. Still occupying the same elegant premises, it has been family-owned for nine generations.

Berry Bros. & Rudd, *St James's*

With immense cellars extending beneath the street and down towards Henry VIII's Tudor palace, this doyen of wine merchants was established in the eighteenth century. As well as old wooden floors, ramshackle Victorian furniture and arts and crafts trappings, its giant leather-bound ledgers contain the personal details of distinguished customers such as Byron, Beau Brummel and his nemesis George IV, King Louis-Philippe and Napoleon III.

James Lock, *St James's*

When the oldest shop in Britain supplied Nelson and Wellington with their distinctive headgear, it was already long established, and it still has the feel of the 1750s. Nelson's hat had a special flip-down eyeshade (on just the one side, of course) and before departing for Trafalgar he called in to settle what turned out to be his final bill.

Paxton & Whitfield, *St James's*

The celebrated cheesemonger arrived here in 1797 having already spent at least half a century running a successful stall at nearby Clare Market. It is very much a relic of the 'old' Jermyn Street, when provisioners and upmarket merchants flocked here to meet the demands of the rich and noble houses clustered around St James's Square and Pall Mall.

LOSE YOURSELF in a LIDO

Fresh air is a bit much to hope for in such a crowded city, but there's no doubt Londoners come out when the sun does, and many like to swim. Inevitably, numbers rise dramatically with the temperature, but there are also hardy types prepared to go out in all weathers and a surprising variety of places for them to do so.

Highgate Ponds, *Hampstead Heath*

Three natural ponds close to the source of the famous Fleet river (one for each sex and a third for mixed bathing) attract scores of regulars who prefer swimming with fish and weeds to the questionable delights of chlorine. A 1961 film called *The Monster of Highgate Ponds* seems not to have deterred them.

Tooting Bec Lido, *Tooting*

The oldest and largest purpose-built outdoor pool in the country. The million-gallon lido was built to give local labourers meaningful employment and 'as a means of affording pleasure, stimulating health and warding off disease' among the working classes. That was in 1906, and despite its art deco glories it's still not heated, but few seem to mind.

The Serpentine, *Hyde Park*

The original 'little bit of seaside in the city'. Open-air swimmers have been active in London for longer than one might imagine: the Serpentine Swimming Club celebrated its one-hundred and fiftieth anniversary in 2014 and members of its Peter Pan Club still meet here for a chilly dip each Christmas morning.

WIDE OPEN SPACES

What Prime Minister Pitt famously described as 'the lungs of London'. Epping Forest on one side and a great arc of 'managed wilderness' on the other make London one of the world's greenest capital cities, even without its several hundred parks and garden squares.

Richmond Park

The largest of the Royal Parks at more than 3.5 square miles, Richmond is what remains of a seventeenth-century deer park created for Charles I. Besides containing rare flora and fauna and buildings of architectural and historical interest, it was an important military training ground in both world wars and subsequently hosted events in both the 1948 and 2012 Olympics.

Bushy Park

Abutting the grounds of Hampton Court Palace and acquired by Cardinal Wolsey, the more than 1,100 acres at Bushy are home to many trees planted on Wren's instruction for William III. With evidence of human settlement more than 4,000 years ago, the park provides a somewhat incongruous setting for the National Physical Laboratory and a seven-step cascade created by the Admiralty in the 1950s.

Epping Forest

Our largest open space once stretched to the Wash and a special Act of Parliament in 1878 was needed to ensure the survival of these last 6,000 acres. It now belongs to the Corporation of the City of London, whose citizens were granted the right to hunt here by Henry III as long ago as 1226. Supposedly a popular place for East End murderers to bury their victims, it is nevertheless good for picnics.

Hampstead Heath

The 800-acre heath became a fashionable watering hole towards the end of the eighteenth century, following the discovery of several 'medicinal' springs. Few places attract more visitors on a sunny bank holiday, but its sheer size means it is still possible to enjoy some peace and quiet away from magnets like Kenwood House and the Old Bull and Bush.

LONG-DISTANCE WALKS

Mark Mason walked the entire London Underground for a book, and Iain Sinclair did the same with the M25, but there are many far nicer long-distance paths through London for anyone with a map, stout shoes and time to spare.

Thames Path

Beginning near Kemble in Gloucestershire, the 184-mile route was first mooted in the years following the Second World War, but it took until the mid-1990s for it to be formally adopted. The stretch from Putney to Greenwich is the most interesting, regardless of which bank you choose.

Regent's Canal

With lengthy tunnels, a dozen locks and more than forty bridges, the canal opened in 1820 and is now an important part of London's industrial heritage. From Paddington to Limehouse it is barely more than eight miles in length, but from the towpath anyone used to seeing London from only the pavement or a bus will be rewarded with some unexpected views of their city.

Jubilee Walkway

A fifteen-mile path opened by Her Majesty the Queen in 1977 links many places of historical and royal significance. These include Trafalgar Square, Parliament Square, Lambeth Palace, Shakespeare's Globe, HMS *Belfast*, the Bank of England and St Paul's Cathedral. The route is clearly marked for walkers by simple stainless-steel roundels set into the pavement.

Diana, Princess of Wales Memorial

Similar in concept to the Jubilee Walkway but only half as long, ninety decorated bronze and aluminium plaques take visitors on a figure-of-eight route around parks, gardens and buildings of significance to the life of the late Princess of Wales. As well as several royal palaces, these include Spencer House, her family's former London home.

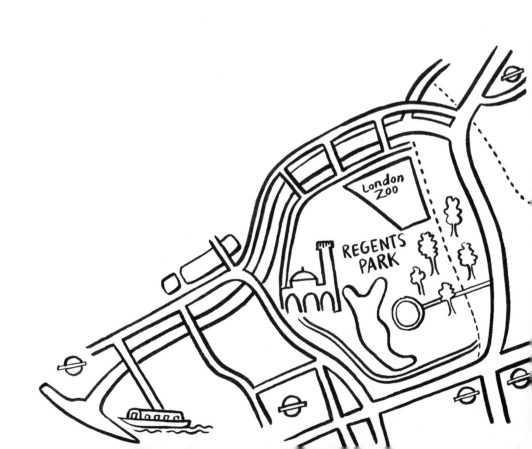

Ancient INNS

One cannot say with any certainty which is London's oldest pub, in part because many have been rebuilt multiple times and others are younger than they look. There are thousands of historic boozers, however; here is a tiny selection.

Lamb & Flag, *Covent Garden*

Popular with bare-knuckle boxers when it was known as the Bucket of Blood, this Grade II listed building is tucked away down a side street and on the right day still has the feel of the seventeenth century despite the shops and tourists crowding round it.

Ye Olde Cheshire Cheese, *Fleet Street*

The board outside lists the fifteen sovereigns enthroned during the pub's long life and although it is not true that Dr Johnson worked here on his dictionary, it is likely he drank here with friends such as Boswell, Garrick, Sir Joshua Reynolds and Edward Gibbon.

The Seven Stars, *Holborn*

Popular with lawyers and friendly, the building has been a pub for at least 400 years, although regulars are still arguing over the derivation of the curious name. Possibly it's a reference to the Dutch League of Seven Stars, from a time when traders from the Netherlands could sail up the nearby Fleet river.

Ye Old Mitre, *Hatton Garden*

Cunningly concealed down the narrowest alley (start your search in Ely Place), Queen Elizabeth may not really have danced with her lover around a cherry tree in the garden, but the stump's been preserved anyway in this lively little sixteenth-century hideaway.

LOO with a VIEW

Visitors to London often lament the lack of public lavatories, many of which have fallen prey to vandals, the march of history and cuts in local government spending. It's probably little comfort to the needy that several have been rescued and reborn, but at least the rest of us can marvel at their new owners' ingenuity and flair.

Art Gallery, *Kennington*

'ArtsLav' is a thriving community hub beneath a busy traffic intersection near Charlie Chaplin's childhood home and the Oval cricket ground. As well as exhibitions, the volunteer team encourages local artists, performers and musicians to use the space, which retains many of its original 1898 fittings.

Café-Bar, *Fitzrovia*

'Attendant' is housed in what was once a late nineteenth-century gents. It's been well reviewed by those who don't mind seeing urinals converted into small seating areas, although with nowhere to expand into it can be slightly claustrophobic.

Home, *Crystal Palace*

In 2011 a young architect took possession of a rubbish-filled loo with permission to convert it into a stylish one-bedroom flat. Top-lit and complete with a tiny private garden and luxurious gold-walled bathroom, the project cost a mere £65,000 to complete, although to achieve this Laura Clark undertook most of the work herself.

Coffee Shop, *Hackney*

A similar concept to Attendant, but with the added amenity of a small roof garden, there's no mistaking the former life of 'The Convenience', where the décor includes a sign warning against the dangers of venereal disease.

END of the LINE

With around forty 'ghost' stations around the capital, London is a fertile hunting ground for anyone with an interest in the strange and subterranean. Some of them enjoyed a long and active life, several closed not long after opening, but surviving buildings at street level mean it is still possible to identify where many of the stations were.

Aldwych, *Piccadilly Line*

Low passenger numbers spelt the end for Aldwych, with several other stations in close proximity and London Transport unwilling to foot the bill for some badly needed lifts. Tours are offered very occasionally and the site is sometimes hired out for films and parties.

Museum, *Central Line*

Said by some to be haunted by an escaped mummy from the nearby British Museum, the station closed in the 1930s and for a while was used for unspecified purposes by the Brigade of Guards.

King William Street, *City & South London Railway*

The station name commemorates a ceremonial route to then-new London Bridge for William IV, and following its closure in 1900 it was left idle until being redeployed as an air-raid shelter during the Blitz.

Lord's, *Metropolitan*

St John's Wood Station was renamed in 1939 for the celebrated cricket ground. Sadly it closed shortly afterwards when a new St John's Wood Station opened on the nearby Bakerloo Line. The next station along the line was closed, too, and converted to a Chinese restaurant, but poor old Lord's was knocked down.

North End Station

Situated on the edge of Hampstead Heath, this one closed before a single ticket had been sold when a planned housing development was abandoned due to public protests about the destruction of heathland.

Marvels of VICTORIAN INDUSTRY

Very few manufacturers still exist in London, yet some of the capital's most impressive structures hark back to the days when the city was the workshop of the world and Britannia really did rule the waves.

Crossness Pumping Station, *Bexley*

Looking at the high vaulted ceilings, astonishing wrought ironwork and immensely powerful steam engines, it is hard to comprehend that such beauty could be associated with sewage. Sir Joseph Bazalgette's temple to waste is a must-see on the rare days when it is open.

Tower Subway, *City and Southwark*

This privately owned tunnel under the Thames immediately west of the Tower of London was devised to run Victorian passengers into the city in diminutive cable cars. The completion of Tower Bridge robbed it of customers and today the only traffic running through it is digital.

London Hydraulic Power Company, *Wapping*

A remnant of a 200-mile network of pipes and tunnels, which for more than a hundred years supplied pressurized water to power lifts, industrial presses and even cranes. Stretching from Earl's Court to Limehouse and south of the river, the technology survived until the 1970s when, finally, it was supplanted by electricity.

Camden Catacombs, *Camden*

Beneath Camden Market an exciting warren of brick vaults and tunnels represent an important transport nexus for mid-nineteenth-century London, complete with a subterranean canal basin, stabling for draught horses and warehousing for the railway yards above.

Glorious GARDEN SQUARES

Some are public and many of the private ones welcome visitors for the annual Open Squares Weekend each June. Otherwise, even viewed through the railings, London's historic garden squares give a wonderful glimpse of the halcyon days when builders could afford to aim for something more elevated than the largest profit from the highest possible density.

St James's Square, *St James's*

Collectively owned by the gentlemen's clubs and grand ducal mansions that surround it, during the week the public can enjoy a surprisingly peaceful oasis in this architecturally impressive corner of the West End.

Eaton Square, *Belgravia*

One of three vast squares built by the Grosvenor family (but actually an elongated rectangle), six separate gardens are set aside for those able to afford what remains London's best address after nearly two centuries.

Soho Square, *Soho*

Dating back to 1675 but no longer residential, the garden's centrepiece is a mock-Tudor *cottage ornée*, for a while used as a gardener's shed. Beneath it lies a huge underground wartime bunker, which was offered for sale for possible conversion to a restaurant.

Finsbury Circus, *City*

The largest public open space in the Square Mile is an ellipse, rather than a square, and after a few years' occupation by Crossrail's construction, we'll soon see its two hectares of green oasis returned to public use.

A CAPITAL'S OLDEST COMPANIES

Despite a relentless obsession with the new, London still boasts some of the most venerable companies in the world.

Twinings (1706)

The Strand tea-seller is famously one of the City of Westminster's oldest rate-payers, having celebrated its three-hundredth anniversary. The address has never changed, although the building itself is not the original.

Whitechapel Bell Foundry (1420)

Responsible for Big Ben and America's Liberty Bell, the foundry buildings are comparatively modern – seventeenth century – but the foundry traces its roots back to the reign of Henry V and has retained at least one customer (Westminster Abbey) for the last 500 years.

C. Hoare and Company (1672)

A Fleet Street institution, this private bank is still in the hands of the descendants of the goldsmith who set up shop here nearly 350 years ago. With at least one of the partners on the premises at all times, the front door can only be locked from the inside as it has no keyhole.

Ede & Ravenscroft (1689)

With branches in the City and West End, the company is best known for its legal and academic robes, but has also clothed royalty, senior military officers and many of the better-turned-out bankers.

THEATRICAL GEMS

London theatres attract more than fourteen million visitors
annually. The forty or so auditoriums are mostly Victorian or
Edwardian, and between them boast some of the city's most
varied interiors, from Romanesque to neo-classical and art deco.
With extravagant detailing and sumptuous decoration, they are
by no means all in the West End.

Apollo Victoria, *Wilton Road*

Slightly severe concrete facades on Wilton Road and Vauxhall Bridge
Road conceal a stylish art deco interior with a cheerfully nautical theme. At
its opening, the *Gaumont British News* described the combination of scallop
shells and faux fountains as 'a fairy cavern under the sea, or a mermaid's
dream of heaven'.

Vaudeville, *Strand*

The scene of Henry Irving's first real success, the Vaudeville popularized
the rich, Romanesque style of decorator George Gordon. Much of this
has disappeared beneath subsequent alterations, mostly because modern
audiences demand to be more comfortably seated than their Victorian
forebears.

Wilton's Music Hall, *Graces Alley*

Far from the West End in Tower Hamlets, this is the world's only survivor
of the original music halls. Popular, well used and slightly down-at-heel (as
perhaps it should be), the narrow, atmospheric auditorium has an elliptical
barrel-vaulted ceiling with a gallery around three sides. Barley-sugar
columns and extensive papier-mâché decoration make this a proper people's
palace.

PAGEANTS & CEREMONIAL

No one does this kind of thing better than the British. Inevitably, most of it is military, and much of it has regal connections, but best of all, with a bit of planning, a lot of it can be enjoyed free of charge.

Changing of the Guard, *Buckingham Palace*

Daily throughout the summer and on alternate days in the winter months, many thousands gather to enjoy the spectacle of two detachments of the Queen's Guard led by the Corps of Drums. Noisy, colourful, and never gets old.

Ceremony of the Keys, *Tower of London*

Every night since the fourteenth century a sentry challenges the Chief Yeoman Warder with the words, 'Halt, who comes there?' Anyone with a ticket can go along to hear this and see what happens next, but with only a handful of tickets each time, the wait can stretch into months. The ceremony was delayed only once – by a bomb in the 1940s – but amazingly it has never been missed.

Trial of the Pyx, *Goldsmiths' Hall*

Once a year the Queen's Remembrancer, a judge of the High Court, presides over this mysteriously named trial in which a jury of goldsmiths inspects newly minted coins of the realm. Their task is to ensure they are of the right size and the metal of an appropriate quality.

Trooping the Colour, *Horse Guards Parade*

Marking the sovereign's official birthday since 1748, several hundred bandsmen and soldiers form up for an inspection by the Queen. Grandstands are provided for thousands of spectators to witness the Household Division do what it does best, on foot and on horseback and with plenty of shouting.

PERFECT Palaces

Including the Tower of London (as strictly one must), the capital has nine palaces, of which seven are royal but only three presently occupied by members of the Royal Family. To these can be added a roll call of lost treasures, such as Bridewell, Richmond, Savoy and Placentia.

Buckingham Palace

By far the best known, this is where Her Majesty stays while in London, although the sovereign's official residence is still St James's Palace, as it has been since Tudor times. The present building is far older than it looks and was given its world famous Edwardian façade by Sir Aston Webb when he redesigned the Mall in 1913.

Kew Palace

Often overlooked by visitors to the gardens (it is rather small), Kew was acquired by George III for £20,000 while a much larger palace was built nearby. Unfortunately the design for the latter was heartily disliked by both his wife and his heir and it was demolished in 1828 without ever being occupied.

Lambeth Palace

The official residence of the Archbishop of Canterbury for more than 800 years (although the oldest part visible from the road, the Lollards Tower, is fifteenth century). Inside are the remains of a 120-year-old tortoise and the only person ever buried on the ten-acre site: Archbishop Matthew Parker in 1575.

Eltham Palace

Glamorously extended by socialites Stephen and Virginia Courtauld in the 1930s, behind the art deco splendour Edward II's old palace was the childhood home of Henry VIII and later a country retreat for court painter Anthony Van Dyke.

ANOTHER MAN'S CHURCH

Observant or not, Christians still predominate, although London's melting pot of religious minorities now includes 12.4% Muslims, 5% Hindus, 1.8% Jews, 1.5% Sikhs and 1% Buddhists. More recent arrivals tend to meet in converted buildings, but the best are bespoke.

Qahal Kadosh Sha'ar ha-Shamayim, *City*

Bevis Marks Synagogue was completed in 1701 and is this country's oldest Jewish house of prayer. More remarkably, although the reasons are not hard to fathom, it is also the only one in Europe that has held Jewish services continuously for more than 300 years.

Shri Swaminarayan Mandir, *Neasden*

One of the most remarkable buildings in the capital, this vast Hindu temple – the first to be purpose-built in Europe – was constructed using traditional methods and materials, principally marble, of which 26,300 pieces were carved by 1,526 Indian craftsmen.

Aghia Sophia, *Bayswater*

The centre of Greek Orthodox life in England, St Sophia's Cathedral was consecrated by the Archbishop of Corfu in the 1880s. The distinctive Byzantine design is by the son of the architect of St Pancras Station and provided a home for the Greek government-in-exile during the Second World War.

Relics of WAR

Blitzed, burned, bombed, built and rebuilt, London has seen more than its share of conflict, but various military relics exercise a continuing fascination, and for anyone who cares to look there are many survivors still to be found.

Cabinet War Rooms, *Westminster*

Actually just a tiny fraction of a vast subterranean complex that comprises six acres of underground offices protected by an immense seventeen-foot shield of concrete. What's been called 'Whitehall beneath Whitehall' was excavated in great secrecy and completed just days before the Germans marched into Poland.

Admiralty Citadel, *Westminster*

One of the most enigmatic buildings in London, the creeper-clad monstrosity facing Buckingham Palace is said to be too well built ever to be demolished. What goes on inside is on a need-to-know basis, and now it's been there so long that most passers-by don't even notice it.

Russian Tank, *Bermondsey*

On a patch of wasteland at the corner of Pages Walk and Mandela Way sits a Soviet tank with its main armament trained on the borough council offices. Stalin's greatest contribution to the war against Germany, besides sheer manpower, was the T-34, which remained in service until 1996 and was a mainstay of more than forty states on both sides of the Iron Curtain.

Eisenhower Centre, *Fitzrovia*

Constructed in 1942 as one of eight vast air-raid shelters (each with room for 8,000 Londoners 100 feet below the surface), twin tunnels nearly 1,200 feet long made this just the thing when the US Army Signal Corps needed an intelligence base on the run-up to D-Day.

PSST, SPY SITES

For more than a hundred years London has held an unrivalled position as the espionage capital of the world. From the foundation of the first Secret Service Bureau in 1909 through the wartime activities of the Special Operations Executive and the Cold War years, not every building associated with this sometimes deadly trade is quite as obvious as MI6's bizarre riverside ziggurat.

Queen Anne's Gate, *St James's Park*

For years the house at No. 21 was the official residence of the head of the Secret Intelligence Service – 'M', if you will – and was connected by tunnel to an anonymous office block at No. 54 Broadway. Spies recruited to MI6 over dinner at the nearby St Ermin's Hotel used to drink at the Old Star pub, and maybe still do.

Selfridges, *Oxford Street*

In the 1940s, in the extensive sub-basements of the famous store, America's Bell Telephone Laboratories installed fifty-five tons of electronics guarded by armed marines. Codenamed SIGSALY, a fake acronym designed to throw the enemy off its scent, this provided a means for Downing Street and the White House to communicate without being overheard or understood.

Portland Place, *Marylebone*

When the Special Operations Executive was ordered by Churchill to 'set Europe ablaze', assistance came from a secret laboratory at No. 35. Here the model for Ian Fleming's 'Q' devised a series of devices for agents in the field, including exploding rats, pens that fired tear-gas and collapsible crossbows. Also suicide pills, should the above malfunction.

East London Cemetery, *Plaistow*

Beginning with a German, Carl Hans Lody, in November 1914, more people were executed at the Tower of London in the twentieth century than in Tudor times. Something had to be done with the bodies and Lody's was buried here beneath a black headstone. Ten other spies joined him, from Germany, Latvia, Holland, Turkey, Sweden and South America, and share a small memorial stone close by.

MESSING ABOUT on the RIVER

Since the dockland redevelopment of both banks of the Thames began in the 1980s, Londoners have been robbed of several fine river views. The best way to appreciate the river is to get out on the water and, besides the aforementioned Duck Tours, there are several ways anyone can do so.

Thames Clipper

As much a bus service as an attraction, vessels ply the Thames between Putney and Woolwich. Along the way the service stops at Tate Modern and Tate Britain, carrying more than 8,000 passengers a day, many working commuters.

Thames RIB

For those who find the Clipper a bit slow, RIBs, or rigid-inflatables, can blast visitors along those stretches of the Thames where vessels are permitted to exceed the normal 12-knot limit. With repeated tight turns, figures of eight and other high-speed manoeuvres, the hour-long white-knuckle ride is conceivably the worst way to see London, but one of the more exciting.

Thames Cruises

From Greenwich to Westminster and as far upstream as Hampton Court Palace, these vessels are rather more sedate. With a hop-on/hop-off service for those using the river to get around, operators also host a number of theme-guided tours with jazz, champagne, canapés and even three-course meals.

Canal Tour, Regent's Canal

Occasional tours are offered through the Stygian gloom of the Islington Tunnel on the narrowboat *Tarporley*. Nearly a thousand yards long, and inaccessible on foot as there has never been a towpath, it is one of the most extraordinary places in this part of London.

WATERSIDE INNS

If you can't get on the river, the next best thing is to find somewhere with a good view, and with so much frontage Londoners are fortunate to have some fantastic riverside pubs.

The Anchor Bankside, *Southwark*

A nineteenth-century rebuild of a much older establishment, and as popular with visitors to Shakespeare's Globe as it must have been in the bard's own time when theatres and bear pits took refuge here from the regulation of the City of London.

Prospect of Whitby, *Wapping*

With early sixteenth-century origins and a 400-year-old stone floor, the Pelican tavern was later renamed after a Tyneside collier that used to tie up alongside to deliver low-grade sea coal to smoky London. A hanging noose commemorates Judge Jeffries (1645-89), who is popularly supposed to have come here to relax during the Bloody Assizes following the Duke of Monmouth's failed attempt to unseat James II.

PS *Tattersall Castle*, *Victoria Embankment*

Other pubs claim to be on the river, but this old Humberside steamer really is. Since Roman times there had been ferries on the Humber estuary, but the completion of the single-span bridge in 1981 rendered them redundant. This one was towed to London and has undergone a multi-million pound refit.

The Dove, *Hammersmith*

Among the finest places from which to watch the annual University Boat Race, for the rest of the year the beamy eighteenth-century interior, vine-tangled conservatory and riverside terrace make this a lovely spot to watch the waves gently lapping. The lyrics to 'Rule, Britannia!' may have been penned here by James Thomson.

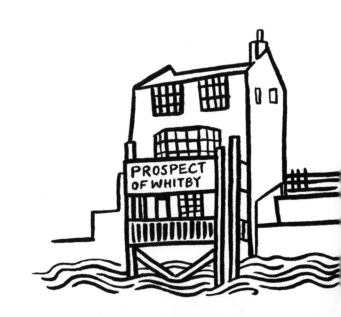

TIMEWARP *interiors*

Where historic streetscapes survive, the reality is that, behind the façades we love, many priceless interiors have been lost or damaged. Happily a few of the best are now protected, often as a consequence of public protest.

Linley Sambourne House, *Stafford Terrace*

An unusually well-preserved late-Victorian Kensington town house was home to a celebrated *Punch* cartoonist, illustrator and photographer, who died in 1910. Retaining its original features, including pictures, furniture and fittings from the 1870s, it also includes a dazzling collection of blue and white Chinese porcelain, as well as myriad miscellaneous objects from the period.

Temple Place, *Victoria Embankment*

Built for the American newspaper and hotel millionaire William Waldorf Astor in 1892, behind a neo-Gothic façade lies one of the most opulent late-Victorian interiors. The expense befits a man who was conceivably the richest American of his day, and the great hall with its roof of carved Spanish mahogany has friezes incorporating more than fifty portraits of leading characters from history and literature.

Denis Severs's House, *Folgate Street*

When the American died in 2000, he left behind a magical living museum, a perfectly restored Huguenot house in which the ten rooms were artfully arranged to encapsulate Spitalfields life from 1724 to 1914. What he called a still-life drama, with candles and fireplaces lit, lingering smells and a jumble of scattered objects, makes it seem as if the family has just popped out for a moment.

SPORTING MECCAS

The inventor of so many sports but famously the master of none, Britain is the fortunate custodian of several world-famous sporting arenas – the home of this or that game – and on the whole is a respectful guardian, with the obvious exception of Wembley Stadium, which was torn down in 2003.

Twickenham Rugby Stadium, *Twickenham*

Playing schoolboy soccer, Essex vicar William Webb Ellis mistakenly picked up the ball and a new game was born. In 1907 the Rugby Football Union developed an old market garden and, with only minor breaks (during the Great War, when cattle were brought in to graze), they've been here ever since. The ground is also used for pop concerts and, since the 1950s, tens of thousands of Jehovah's Witnesses have crowded into the stands for their annual Bible reading.

Hurlingham Club, *Fulham*

Established as a place to shoot pigeons for points, in 1873 members formalized the rules of polo before going on to host the polo rounds of the 1908 Olympics (Britain won all the medals after entering three teams to the rest of the world's none). With a lengthy waiting list for the club itself, the game is no longer played here, but the governing body is still known as the Hurlingham Polo Association.

The Oval, *Kennington*

Very much the Hawker Hurricane to Lord's' Spitfire, the history of the Surrey County Cricket ground is nevertheless more varied and far more interesting. For example, it was here, not Lord's, that the first ever international Test match was played in 1880. Also, the first-ever F. A. Cup Final (1872), the first soccer international (1870) and rugby's first Varsity Match in 1877. Later it was converted into a gigantic prisoner-of-war camp for Nazi paratroops, and perhaps best of all it is still owned by Prince Charles as the present Duke of Cornwall.

STANDS the CLOCK at TEN to THREE?

We have Anna Maria Russell to thank for the institution of afternoon tea. The wife of the 7th Duke of Bedford introduced it at Woburn Abbey in the 1800s, partly to boost the profits of the family's Chinese trade and also to stave off her own hunger between luncheon and dinner. Today few have the time to indulge in the daily ritual, but as a special treat it can still be very special indeed.

The Waldorf-Hilton, *Aldwych*

The street outside is grubby and noisy but inside is a calm, peaceful oasis. As the perfect encapsulation of the Edwardian era, the Waldorf's finest feature – a magnificent, elegant, glass-roofed Palm Court – must be counted among the most evocative survivors left in London.

Fortnum & Mason, *Piccadilly*

Ever-delightful Fortnum's has been selling its own teas for more than 300 years and recently revamped its Georgian-style tea salon for the Queen's Diamond Jubilee. From Darjeeling Jungpana through Jeju-Do Island Seogwang Green to a simple Breakfast Blend, it's the connoisseur's choice, accompanied by a variety of savouries and small, elegant cakes.

BB Routemaster, *Trafalgar Square*

The popular tea-bus tour is a genuine movable feast, combining sightseeing, a ride in an authentic London icon and a proper high tea with homemade sandwiches and delicious pastries and cakes. What it lacks in grandeur compared to the *hotels de grand luxe* it more than makes up for in terms of quirky fun.

UNSPOILT STREETS and SQUARES

Assailed by noise and dust, Londoners like to say the place will be wonderful when it's finished. Indeed, much has been lost to developers, but a good deal has survived, and on both sides of the river it is still possible to find some perfect examples of practical urban planning.

Goodwin's Court, *Covent Garden*

Entered through what is really no more than a doorway, this charming little alley off St Martin's Lane dates back to 1690. Little known, it is still lit by large gaslights, and the wonky bow-windows, brass door furniture and black glazing bars make it a wonderfully evocative place.

Great James Street, *Bloomsbury*

Despite plenty of rebuilding behind the façades, from the pavement the street presents an almost unchanged picture of a typical, high-status street of the 1720s. Much of it is still residential, too, with past occupiers including Dorothy L. Sayers, T. S. Eliot, and Leonard and Virginia Woolf.

Trinity Church Square, *Southwark*

The most complete square south of the river was begun in 1813. William Chadwick's plan to 'form the Square round the new Church' was a new concept in town planning. Now renamed the Henry Wood Hall, the Italianate Holy Trinity is a rehearsal space for the London Symphony and London Philharmonic orchestras.

Woburn Walk, *Bloomsbury*

With a small but diverse range of shops still selling books, prints, food and antiques, what might be termed London's first pedestrian shopping precinct was built in 1822 by Thomas Cubitt for the 6th Duke of Bedford, who owned most of the surrounding area. W. B. Yeats lodged above one of the bow-fronted shops from 1895 to 1919.

RUS in URBE: LONDON'S COUNTRY HOUSES

London's rapid expansion beyond its original walled core made it a global powerhouse by the nineteenth century, but at great cost to many of its citizens and a good deal of lush countryside. Nearly 400,000 acres of the latter disappeared for good under streets needed to house dockers and factory workers, and several rural and semi-rural retreats found themselves cut off and surrounded.

Kenwood House, *Hampstead*

With more than a hundred acres of grounds and its own dairy, this compact country estate was bequeathed to London by the Guinness brewing family. The house dates from 1700 but was extensively remodelled by Robert Adam a hundred years later. A hundred years after that it provided a home for a grandson of Tsar Nicholas I of Russia, effectively exiled after marrying outside his class.

Chiswick House, *Chiswick*

According to Horace Walpole, 'too small to live in, too big to hang on a watch', the 3rd Earl of Burlington's Georgian dream of recreating the Palladian idyll west of London draws a million visitors a year to what are also England's first landscape gardens. George Canning died here in 1827 (after just 119 days as prime minister), but there are worse ways to go than surrounded by the decorative temples, ornamental cascade and charming follies designed by Burlington's collaborator William Kent.

Sutton House, *Hackney*

Originally called Bryck Place and built in 1535 by a senior courtier of Henry VIII, its later occupants – traders and sea captains, Huguenot silk-weavers, Victorian schoolmasters and Edwardian clergy – capture the changing tone of an area in decline. Eventually taken over by trade unionists and then squatters, it has since been rescued by the National Trust.

ROOFTOP CHIC... and FRANK'S

With many historic streets too narrow to allow bars and cafés to spill out on to them, one of the most effective solutions has been to look up. London now has more roof terraces than ever before, and while some are admittedly rather small – more balcony than garden – it's always better looking down on a traffic jam than staring directly up its exhaust.

Roof Gardens, *Kensington*

Unbeatable after nearly eighty years, an acre and a half of landscaped gardens with mature trees, limpid pools and captive flamingos, the original cost of £25,000 was offset by charging visitors a shilling (5p) to enter, but today it's free, providing the place has not been reserved for a private party.

The Berkeley, *Belgravia*

Seven storeys up, with a vast sliding roof, this is the only West End hotel where one can enjoy a poolside drink al fresco.

Sushisamba, *City*

Perched thirty-eight storeys above the Square Mile, the theme is unusual – Brazilian/Japanese/Icelandic – but the views are quite spectacular during the day and especially after dark.

Vista, *Trafalgar Square*

For a new view of an old friend – one can almost look Nelson in the eye-patch – the roof terrace of the Trafalgar Square Hotel makes the most of this enviably central location.

Frank's Café and Campari Bar, *Peckham*

Frank's is open for just a few weeks each summer and, unlikely as it sounds, occupies the top of what would otherwise be a wholly unpromising south London multi-storey car park. Attracting rave reviews, it's a good deal cheaper than many rivals and with its 360-degree vista, just as good.

VESSELS to VISIT

Back on the river, an array of ships bear witness to London's long maritime history. Recognizing that from the earliest days of Roman Londinium it is international trade that has made London the place it is today, it seems wholly appropriate that so many historic vessels are still moored on or near the Thames.

Golden Hind (1577), *St Mary Overie Dock, Southwark*

Admittedly, this is only a replica of Francis Drake's celebrated circumnavigator, but since 1973 she has logged more than 140,000 ocean-going miles, including a complete round-the-world tour.

Cutty Sark (1869), *King William Walk, Greenwich*

The last surviving great tea-clipper was badly damaged by fire in 2007, but following a five-year restoration now looks better than new. As fast as she is elegant, a top speed of 17.5 knots meant her performance was outstanding for her day and her fastest time back from Australia remained unbeaten for years.

SS *Robin* (1890), *Royal Victoria Dock, Newham*

The world's oldest steam coaster was built in Bow Creek and served dozens of Channel and North Sea ports. Sold to Spanish owners in 1900, she was found by the Maritime Trust nearly three-quarters of a century later and rescued from the breaker's yard.

HMS *Belfast* (1939), *Queen's Walk, Southwark*

Seeing action on D-Day, on the Arctic Convoys and in the Korean War, following retirement in 1963 the mighty Town-class cruiser was handed to a private trust and then the Imperial War Museum to ensure her survival. Her main armament, Mk. XXIII six-inch guns, can fire eight rounds a minute per barrel and are trained on the M1 Scratchwood Services.

Fabulous FOLLIES

As surprising as ruins in London are the survival of more than sixty curious and decorative follies. Some originally graced country parks and have been swallowed up by London's relentless expansion but others, such as Queen's Tower, have been urban from the start.

Queen's Tower, *South Kensington*

Nearly 300 feet high yet all but invisible from the streets below, Britain's tallest folly is the sole survivor of the once mighty Imperial Institute. Established as a place of study and education to mark Victoria's 1887 Golden Jubilee, the tower narrowly escaped demolition following a public outcry in the 1950s.

Severndroog Castle, *Shooters Hill*

On a relatively high, wooded hill in south-east London, this charming triangular Georgian-Gothic tower commemorates the capture of Suvarnadurg in the East Indies. It was built in 1784 by Lady James in memory of her husband, Sir William, whose 'superior Valour and able Conduct' won the day.

St Antholin's Spire, *Sydenham*

An obelisk in the middle of an ordinary 1960s housing estate is actually the top-most portion of a Wren church from the City of London. The spire of St Antholin, Watling Street was replaced in the 1820s and the original sold to a local landowner for £5. He put it in his garden, which was subsequently built over.

Turkish Hamam, *City*

Nevill's Turkish Baths opened beneath Bishopsgate churchyard in the 1890s with this curious Moorish structure as its above-ground entrance. One of the most delightful little buildings in the area, once the fashion for steam evaporated it provided a home for a succession of restaurants and cafés.

SENSATIONAL CINEMAS

The glory days may be long gone for lovers of the silver screen, but even converted, London's finest cinemas provide an evocative reminder of a time when for many this was *the* big night out.

Gala Bingo, *Tooting*

England's first ever Grade I listed cinema was designed in the 1930s by Russian theatre impresario Theodore Komisarjevsky. The soaring, intricately Gothic interior of the 3,000-seat auditorium is decorated with huge painted murals of troubadours and other traditional medieval figures. Before becoming a bingo hall, entertainment was provided by a four-manual, fourteen-rank Wurlitzer organ – the country's largest – which is still in situ.

Rivoli Ballroom, *Crofton Park*

Now the last 1950s ballroom in London, the simple barrel-vaulted auditorium of the old Picture Palace screened its first silent film in 1913. It remained in business for the introduction of talkies and then colour, but growing numbers of teenagers with cash to spend meant it was converted to a rock 'n' roll dance hall in 1959.

Gaumont State, *Kilburn*

The name is a nod to its most prominent feature, a central tower clearly modelled on the Empire State Building, although at 120 feet it is something under one tenth of the latter's height. It's big inside, however, and with a capacity of 4,004 was Britain's largest cinema when it opened in 1937.

Phoenix Cinema, *East Finchley*

London's oldest purpose-built cinema still in operation, the Grade II listed Phoenix underwent a spectacular million-pound refurb to mark its one-hundredth birthday.

A WINDOW on the UNIVERSE

The Astronomer Royal may have abandoned London for cleaner skies, but despite the horrific pollution (light and otherwise), the city still has a surprising number of observatories and planetariums from which amateurs and professionals alike can enjoy the strange magic of the stars.

Royal Observatory, *Greenwich*

The 'home of Time' straddles the prime meridian and has done so since 1675. Its primary purpose was naval, charged with rectifying 'the tables of the motions of the heavens, and the places of the fixed stars, so as to find out the so much desired longitude of places for the perfecting of the art of navigation'. It is still an inspiring spot, despite the crowds.

University of London, *Mill Hill*

Constructed in the 1920s and now part of University College, the observatory is a private teaching and research facility but hosts public talks and tours once a fortnight during the autumn and winter.

Hampstead Scientific Society, *Hampstead*

Established in 1899, the astronomical observatory near Whitestone Pond is open to the public on clear nights only each Friday and Saturday from September to March. The equipment is old but, despite this (and the amateur nature of the place), it's a real find.

First published in Great Britain in 2016 by
Michael O'Mara Books Limited
9 Lion Yard
Tremadoc Road
London SW4 7NQ

A CIP catalogue record for this book is available from the British Library.

Papers used by Michael O'Mara Books Limited are natural, recyclable products
made from wood grown in sustainable forests. The manufacturing processes conform
to the environmental regulations of the country of origin.

ISBN: 978-1-78243-556-3 in paperback print format

1 3 5 7 9 10 8 6 4 2

Cover illustrations by Kate Forrester
Cover design by Simon Levy
Typeset by K.DESIGN, Winscombe, Somerset

Printed in China

www.mombooks.com